TADCASTER
HISTORY TOUR

First published 2017

Amberley Publishing
The Hill, Stroud,
Gloucestershire, GL5 4EP
www.amberley-books.com

Copyright © Paul Chrystal, 2017
Map contains Ordnance Survey data
© Crown copyright and database right
[2017]

ISBN 978 1 4456 7730 9 (print)
ISBN 978 1 4456 7731 6 (ebook)

British Library Cataloguing in
Publication Data.
A catalogue record for this book is
available from the British Library.

Origination by Amberley Publishing.
Printed in Great Britain.

ACKNOWLEDGEMENTS

Thanks to David Skillen, Towton Battlefield Society, for the image on page 47.

By the same author:
Vale of York Through Time
Selby & Goole Through Time
Tadcaster Through Time
Leeds in 50 Buildings
Historic England: Leeds
York in Picture Postcards

For a full list please visit www.paulchrystal.com

INTRODUCTION

This is a condensed edition of my *Tadcaster Through Time* – a kind of 'best of', if you like; a pocket-sized greatest hits of the best things to see in Tadcaster. Richard Jackson got it about right in 1877 when he described Tadcaster as follows in his *Illustrated Guide to Yorkshire*:

> Of all the landward towns in that great haughty shire,
> Old Tadcaster on Wharfe the highest may aspire;
> To her belongs a grace that ever will avail
> In her right honest meal, and, better still, her ale;
> For there the sovereign draft its power may never fear,
> As it can elsewhere find no rival, and no peer.

Think of Tadcaster and you think of breweries and beer. The town has been brewing since 1341, but it really came into its own when domestic production was industrialised by the Smith family and others at the end of the nineteenth century, leaving a legacy in the shape of Samuel Smith and John Smith, complemented today by a third, Molson Coors Brewing Co. Harry Speight, writing soon after Jackson, attests that beer was in the air: 'In our walks about Tadcaster certain odoriferous breezes make us conscious of the presence of these famous breweries ... Tadcaster air is surcharged with the extract of malt.'

The good brewing water from springs or popple wells around the River Wharfe inspired the development of beer production here; add to that the importance of Tadcaster as a staging post on the London to Edinburgh road and, along with the three breweries, you begin to

understand the plethora of inns and taverns in the town. It was vital that the town provided accommodation and refreshment for both man and horse. But it isn't all beer and skittles here, and spring water isn't the only natural resource that makes Tadcaster famous: Tadcaster magnesian limestone has long been highly sought after and many iconic English buildings, including York Minster no less, are built with it. The Romans knew all about this stone and called their settlement here Calcaria.

The River Wharfe and its bridges are, of course, central to the town and account for its very existence and development. There are many fine buildings around Tadcaster that survive from as far back as the fifteenth century: the oldest, the Ark, has been serving the community for many years and still does today as local council offices; the striking viaduct, ever redundant as a means of crossing the Wharfe in a passenger train, now forms part of an enjoyable town walk; and from St Mary's Church a beautiful William Morris window shines out.

The villages around Tadcaster are especially important for their military history. Towton was the site of England's biggest and bloodiest battle during the Wars of the Roses, while 600 years later Thorp Arch turned out pieces of ammunition by the million during the Second World War. The peaceful and cerebral Boston Spa is now the home of the northern British Library, and Bramham Park hosts the Bramham Horse Trials and Leeds Festival each year. The pub sign at The Wild Man in Street Houses was once very nearly a cause of embarrassment to Queen Victoria on her way to York.

All of this is covered in this book – in old pictures with incisive, informative captions. It is, therefore, a brief, pictorial history of Tadcaster and the surrounding area, which can be read straight through or dipped into page by page.

Paul Chrystal, York
July 2017

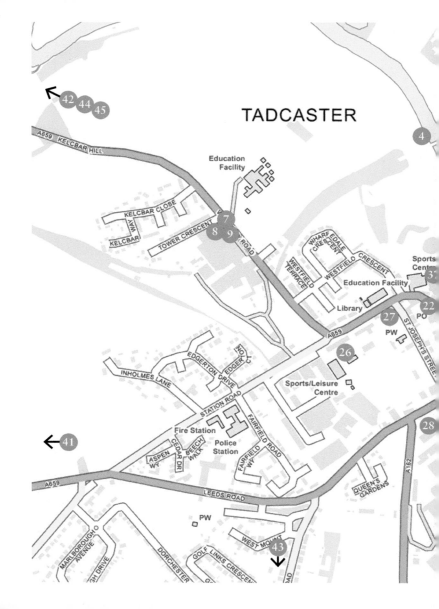

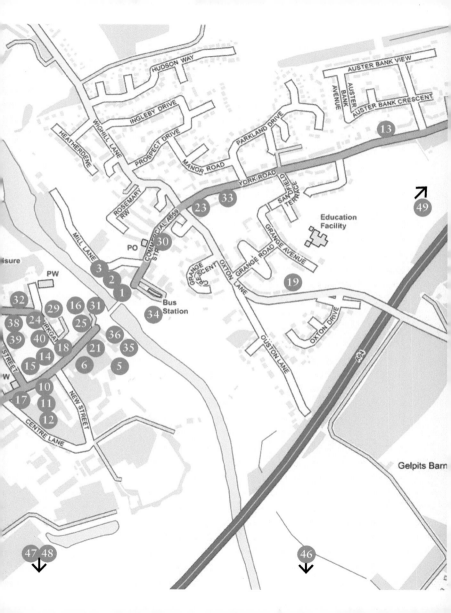

1. TADCASTER BEACH, 1933

A popular summer's day out for both locals and day trippers from the towns of the West Riding looking for somewhere nearer and cheaper than Scarborough or Filey. Tadcaster was founded by the Romans, who called it Calcaria, from the Latin word for lime, reflecting the limestone deposits that have been quarried there for centuries. Many famous buildings, including York Minster, are built from Tadcaster limestone, the stone being conveyed by boat to York (*'per navem a Tadcastre usque Ebor'*). According to the fabric rolls in the Minster, it was still going on in 1403: 'caryying *unius* shypfull *petrarum per aquam'* – 0/10 for the Latin.

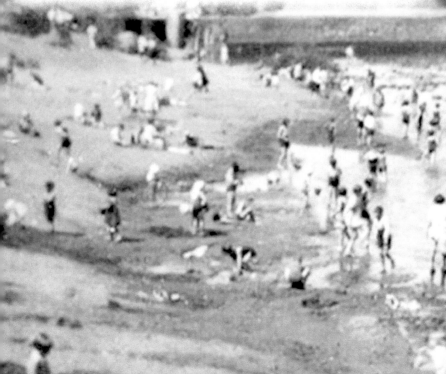

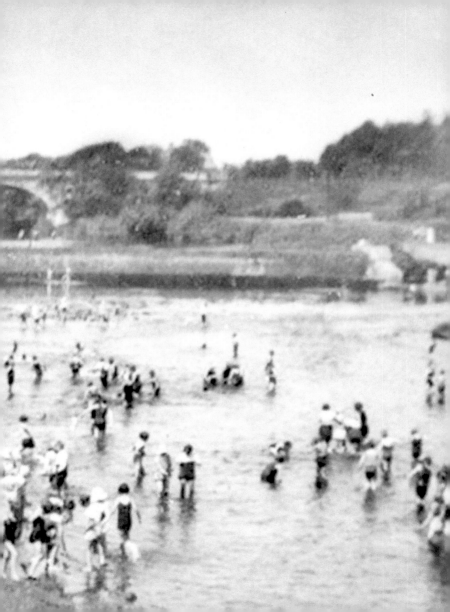

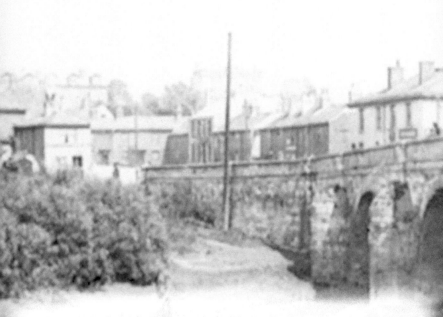

2. TADCASTER BRIDGE

The original river crossing was a ford near the present site of St Mary's Church, followed by a wooden bridge. Around 1240, the first stone bridge was built nearby from stone quarried from the castle. We know that there has been a bridge here from the thirteenth century, although the present bridge dates from around 1700 and was subsequently widened in 1780 by John Carr. The bridge formed the boundary between the Ainsty and the West Riding until 1835 and it was here that royal visitors would be met and escorted on to the city of York.

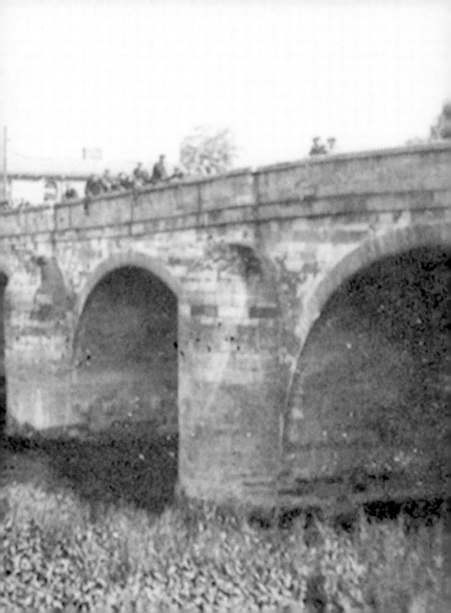

3. TADCASTER BRIDGE AND A MAROONED SWAN

The bridge was described in 1540 by Leland, the king's surveyor, as having '8 faire arches of stone. Sum say there that it was laste made of part of the ruines of the old castelle'. Tadcaster was the Parliamentary headquarters during the Civil War in 1642. At 11 a.m. on Tuesday 7 December 1642, the Battle of Tadcaster took place around Tadcaster Bridge between the Parliamentarian Sir Thomas Fairfax's 900 men and the Earl of Newcastle's 8,000-strong Royalist army. The Royalists took the town. Tadcaster Bridge was, of course, severely damaged during the flooding of Christmas 2013, effectively cutting the town in half and necessitating a long detour just to get from one end of the town to the other. The damage to local businesses was inestimable – it was not until 2017 that this artery was finally reopened. The town has nevertheless fully recovered and is thriving again.

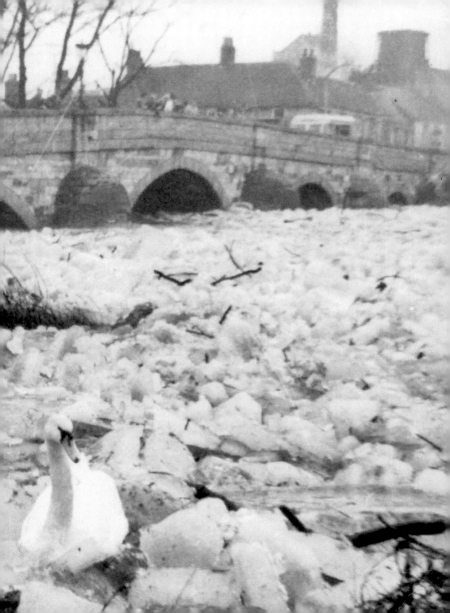

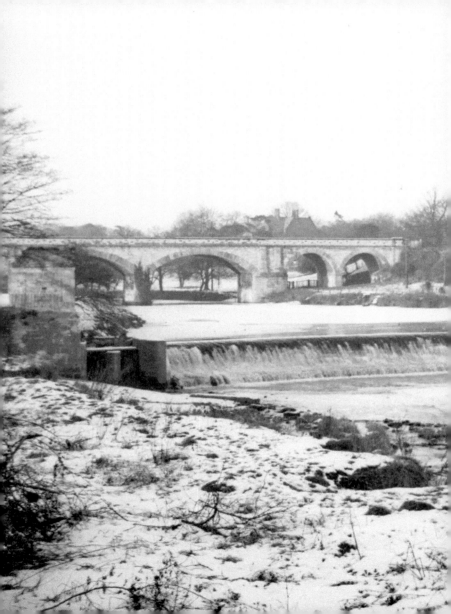

4. HUDSON'S FOLLY AND THE WEIR

A quarter of a mile above the Wharfe Bridge, an imposing viaduct of eleven arches spans the River Wharfe. This was built as part of the projected Leeds–York railway promoted by the industrialist George Hudson, 'Railway King', for the North Midland Railway. The go ahead for the line was given in 1846: it was to run from Copmanthorpe to Cross Gates, meeting the Church Fenton to Harrogate line between Tadcaster and Stutton. Unfortunately, Hudson's financial problems in 1849 and the marshy land under the tracks meant that the line was never completed and the viaduct was only ever used by trains taking coal to Ingleby Mills from 1882 to 1955. The need for the line evaporated completely with the opening of the Micklethorpe to Church Fenton line in 1869. A Grade II-listed building, it is now the integral feature of the Viaduct Walk, which starts at the Wetherby Road. It was bought by the town council from British Rail for £100 in 1980.

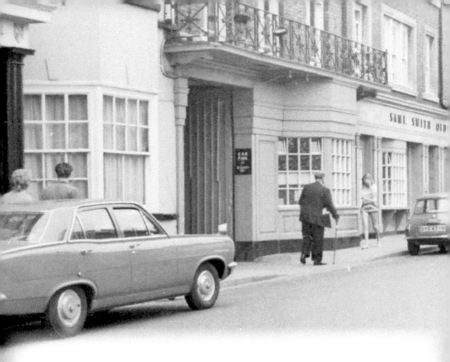

5. SAM SMITH'S OLD BREWERY OFFICES

The Old Brewery at Tadcaster on the left here was established in 1758. It is the smallest of the three Tadcaster breweries, independently run, and the oldest brewery in Yorkshire. The original well was sunk in 1758 and is still used today; the water for the beers is drawn from 85 feet underground. Samuel Smith still ferments ale and stout in traditional Yorkshire stone 'squares' – roofed fermenting vessels made of solid blocks of slate. The strain of yeast used today has been used at the Old Brewery continuously since the beginning of the twentieth century; it is one of the oldest unchanged strains in the country. The brewery cooper makes and repairs all the wooden casks used for the brewery's Old Brewery Bitter.

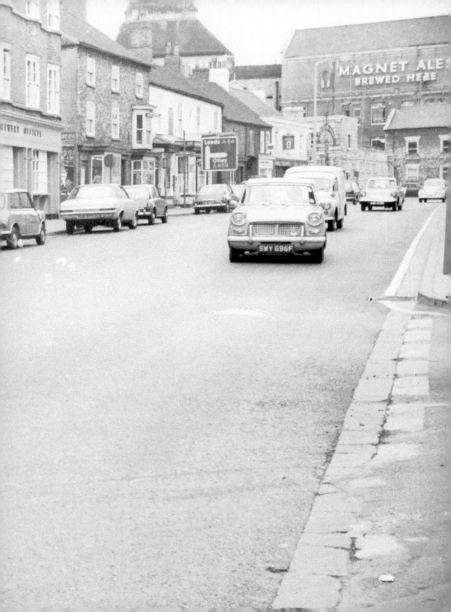

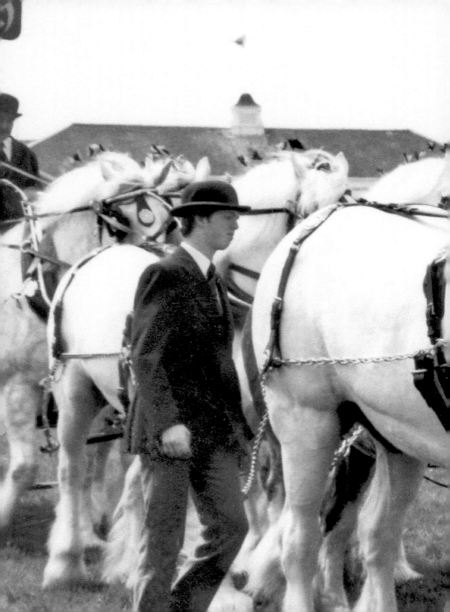

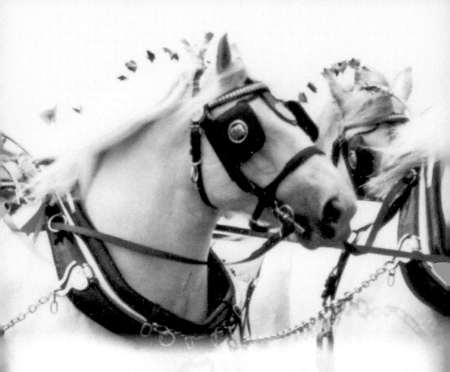

6. SHIRE HORSE DELIVERY

Magnificent grey shire horses weighing more than a ton each are stabled at the Old Brewery and still deliver to some local pubs. The first evidence of brewing in Tadcaster is in early tax lists, which indicate the presence of brewhouses in 1341. Around 1400, good ale sold for 1½*d* per gallon; by 1500 the price had doubled. In the seventeenth century most of the brewhouses recorded were supplying large houses, inns or posthouses. The 1378 poll tax returns show the population of Tadcaster to have been 400 including two brewers, five innkeepers, three merchants, one draper, four wrights or blacksmiths, a dyer, tailor, mason and two shoemakers. The rest were employed in agriculture.

7. SNOBS' BREWERY

This brewery was built on land bought for £484 from George Hudson's ill-fated North East Railway in 1882, at the end of Wetherby Road and bound by the Harrogate line and the branch line to the viaduct. Tower Brewery earned its nickname from the aloofness of the original owners: affluent young men from fashionable York who rarely came to Tadcaster and remained somewhat mysterious to local townsfolk and even the workers. The owners were in fact Hotham & Co. – brewers of York in George Street since 1716 who also owned ninety of the 284 pubs in the city around 1870. In 1875 Hotham's sold up for £36,000 to a consortium of York and London businessmen, who promptly bought Yates's brewery in York for £12,000 including a further twelve York pubs. The new owners were in their late twenties, old Etonians, and shared a passion for horse racing, which they were **able to indulge** at the Knavesmire. The company changed its name to **the Tadcaster Tower Brewery Co. in November 1882. The old picture shows brewery drays setting off for a delivery and North Eastern steam engines in the yard on the lines that served the brewery.**

TADCASTER TOWER BREWERY
TADCASTER

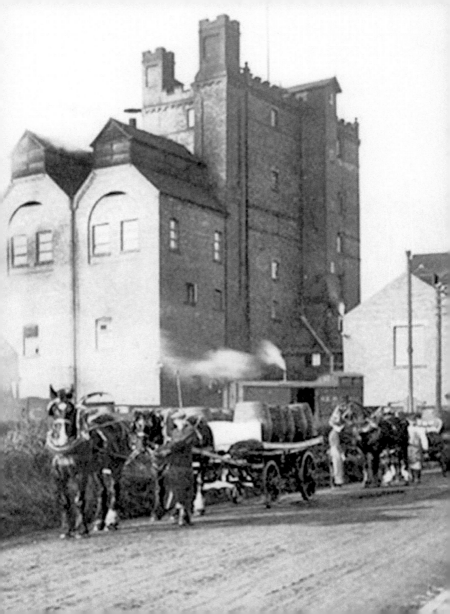

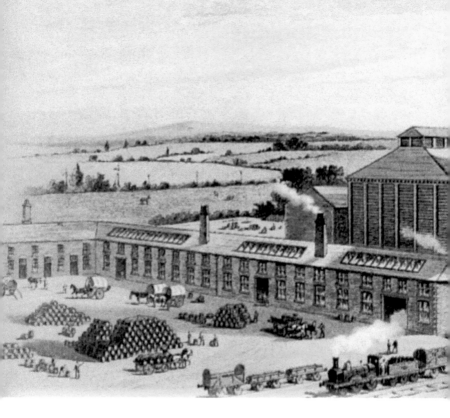

8. TOWER BREWERY

The decision to relocate to Tadcaster had been largely based on the superiority of the water here, the town's importance as a staging post for goods traffic and the fact that it was a railway town; no doubt the reputation of Samuel Smith's and John Smith's also had something to do with the decision. Tower Ales were supplied as far afield as London and the company became agents for porter from Watney,

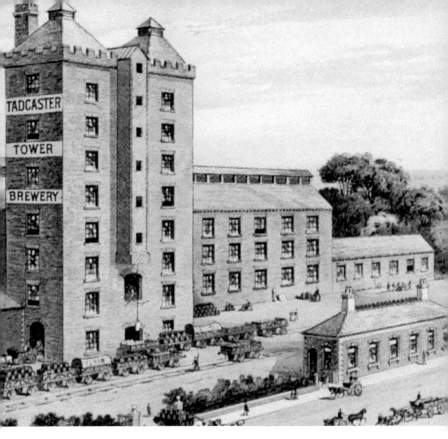

Combe & Reid. Tower also became a key supplier to the army at Strensall Camp north of York. In 1885 the brewery employed nineteen men at Tadcaster including two coopers from Burton's (malting and bottling remained in George Street, York). The weekly wages bill was £21 5s 4s. In 1884 Tower bought Mitchell's Whitwood Mere Brewery, Castleford, and nine pubs. In 1888 they bought the twelve pubs and brewery of Edward Smith, Grimsby. Production at Tadcaster in 1893 was 74,660 barrrels; the company owned 280 pubs and off-licences.

9. TOWER BREWERY: HAMMONDS – CHARRINGTONS – BASS – COORS

Ronald Castle's brewery in Chapmangate, Pocklington, was bought in 1921 along with ten pubs, but the main event that year was the launch of a new bottled beer, originally called Pale Ale but changed to Prize Medal – an auspicious choice in view of the medals it won over the years. Resistance to this bottled beer ran high among drinkers and from the Tower Brewery coopers – how could beer in a bottle taste as good as a beer from a cask?. In 1926 total output for all beers, including bottled, was 54,000 barrels. Tower Brewery was taken over by the large 700-pub Bradford brewery Hammonds in 1946, then Charringtons in 1962 and then the Bass group in 1967. Today it is part of Molson Coors Brewers Ltd, formed in 2002 by the merger of the Coors Brewing Co. in the USA and most of the former Bass Brewers in the UK.

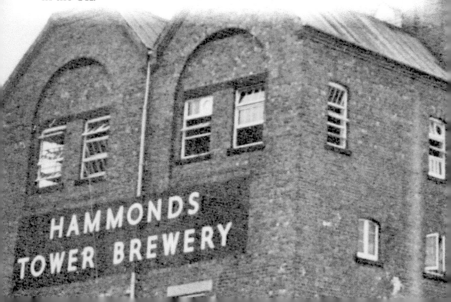

10. JOHN SMITH

John Smith was the son of a tanner from Meanwood in Leeds. He acquired the ramshackle Backhouse & Hartley Tadcaster Brewery in 1847. When Lord Londesborough's estate was sold off in 1873, John Smith bought a large portion of land along Centre Lane and built a new brewery. John died in 1879 and did not see his £130,000 building, which opened in 1883. His brothers, William and Samuel, inherited the business and by 1890 they were producing 3,000 barrels a week; Samuel's son, Samuel Jr, then proceeded to re-equip the Old Brewery and reopen it in his own name in 1886 in competition with the established firm of John Smith's.

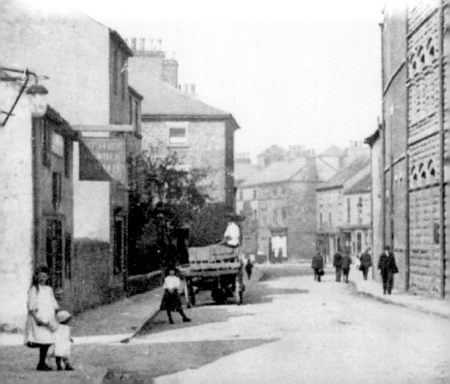

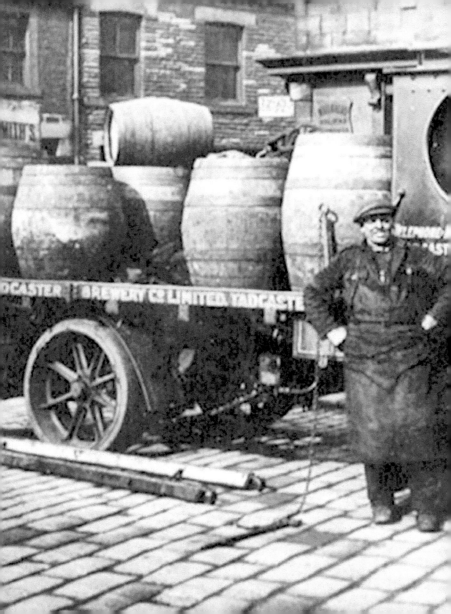

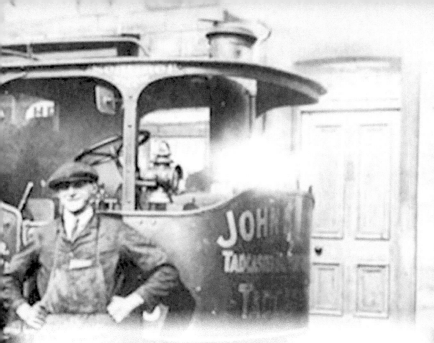

11. JOHN SMITH STEAMING

A steaming John Smith's steam wagon delivering casks. Arthur Waters was the driver and his drayman was Bill Parker. Tadcaster had other breweries in the early days. In the 1870s Benjamin Braime started a small brewery (the Victoria Brewery) next to the new John Smith brewery; another business, Wilson and Cundall, opened up in Maltkin Square, the site of the current central car park. It ceased trading after 1893 and its premises were taken over by Benjamin Braime, who then sold the High Street brewery to John Smith's. Braime's Brewery continued in Maltkin Square until 1906 when it too went bankrupt. Braime's Brewery in Malt Kiln Square was another early Tadcaster brewery formed in 1895 by the amalgamation of Wilson & Cundall's New Brewery and Braime's Victoria Brewery.

12. DELIVERING PARTS TO JOHN SMITH'S

Delivery of some crucial equipment to the brewery and pausing for a photograph. The magnet trademark was registered in September 1908 in Brussels and symbolises strength. The description on the certificate (No. 43449) reads: '*cette marqueé represente un aimant surmonté du mot – Magnet*'. Wills in the 1720s indicate that brewing could be very lucrative: Thomas Morris left eighty-five gallons of beer, four hogsheads and sixty barrels with accounts as far away as the White Swan in York. Thomas Beaumont left eighty quarters of malt and lots of equipment – a business that ultimately led to the establishment of John Smith's.

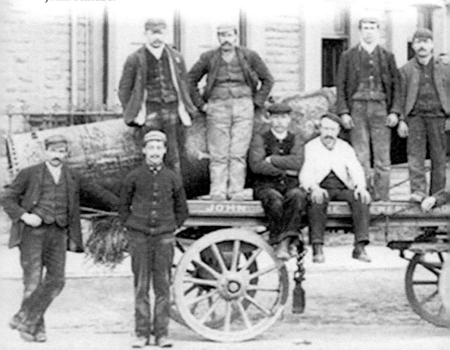

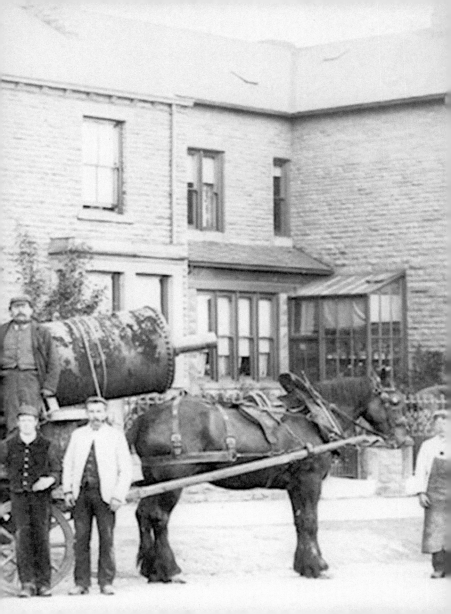

13. THE TRAVELLING MAN

Opposite the Leeds Arms, The Travelling Man opened around 1855 and was bought in 1896 by John Smith's. It was demolished around 1975 and replaced with modern housing; its licence wasn't renewed in 1968, although Tadcaster justices did agree to grant a licence for a new pub in its place in Stutton Road – The Jackdaw. In 1797 the occupant Hannah Whitehead was officially described as such: 'Remark – this tenant is very old and industrious and the rent [4s per annum] must remain for her life as present – she built it and the income arising from underletting them supports her.'

14. THE GEORGE & DRAGON

Originally at No. 18 High Street, it was first called the Black Swan and then The George – all before 1830. It was owned by the chantry chapel of St Nicholas' in St Mary's Church around 1548 and featured 1592 stained glass in the window, which pictured a Tudor rose and the initials 'W. K.' – the sign of The George, who belonged to the chantry of St Nicholas. The square archway to the right was knocked down in the 1900s after a drayman was decapitated while delivering in his horse and cart. It is now Tykes Tearooms.

15. THE ANGEL COMMERCIAL INN

Known in Tudor days as the Red Hart, the Angel still retains some of its Tudor architecture in the doorway; it closed in 1855 to make way for the Londesborough Arms. Next door was the White Horse, a coaching inn hit hard by the arrival of the railways and which closed temporarily in 1840. However, Lord Londesborough needed somewhere to put up his guests on race days and so those he could not accommodate at Grimston Hall were, after 1855 when he reopened it and renamed it the Londesborough Hotel, offered rooms here. Matthew Kidd was landlord of the Angel when it was sold to Lord Londesborough; part of the deal was that Kidd became landlord of the Londesborough. It finally closed in 1976 to become the offices of Sam Smith's brewery.

TADCASTER.

ANGEL COMMERCIAL INN
AND POSTING HOTEL.

MATTHEW KIDD

Grateful for the patronage bestowed on his late Mother, respectfully informs the Nobility, Clergy, and Gentry, of Tadcaster and the Neighbourhood, and the Public generally, that he will continue to carry on the business of the above inn and Posting House, and hopes by the strictest attention to every department of the Establishment, to merit a continuance of their support.

GOOD POST HORSES, NEAT POST CHAISES, CABS, GIGS, &c., ON THE SHORTEST NOTICE.

Superior accommodation for Commercial Gentlemen, &c.

Tadcaster, Aug. 1st 1843.

d

16. THE RAILWAY HOTEL

The Bull & Dog coaching inn changed its name to the Railway Hotel in 1837 when it was acquired by the Wharfedale Brewery of Wetherby from the 6th Duke of Devonshire. In 1856 the then landlord Godfrey Braim was the victim of an early rail accident: he died in a collision at Church Fenton while returning from the Market Weighton Agricultural Show. Full details can be found on his tombstone in St Mary's. Braim's successor, William Proud, eyeing the rise of the railways, established a shuttle coach service to Bolton Percy station 'to meet every train during the day'.

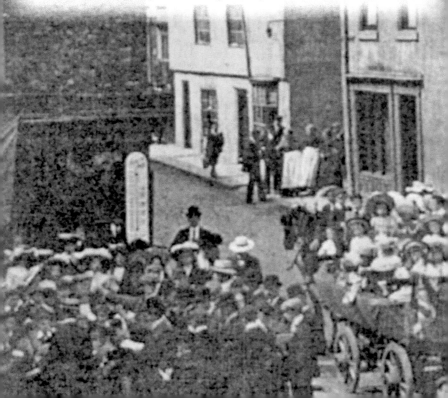

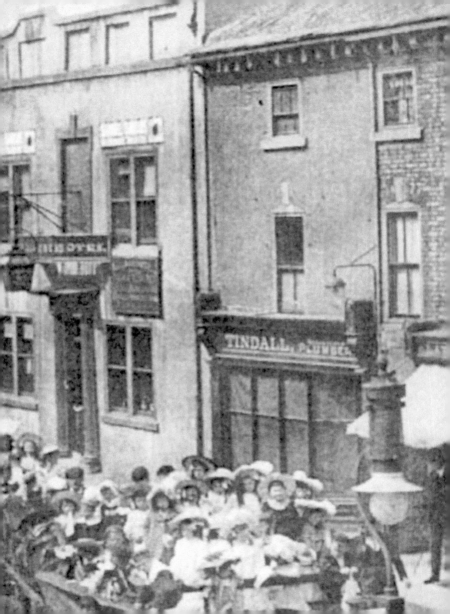

17. JOHN SMITH BREWERY

A modern look at the premises of the John Smith Brewery in Tadcaster. Its best-known brand is John Smith's Yorkshire Bitter, one of the leading brands of bitter in the United Kingdom.

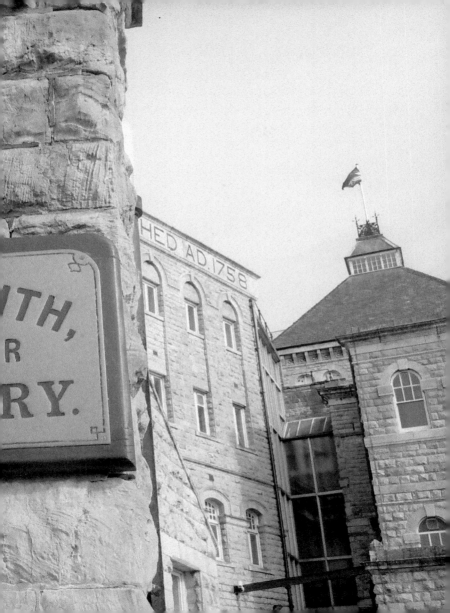

18. THE OLD FALCON

The Old Falcon was part of the Ark building in Kirkgate and was run from 1822 for over 100 years by the Liversedge family. In 1844, Thomas Liversedge was also a lime burner. The pub was the last free house in Tadcaster until John Smith bought it in 1942, with it closing soon after the Second World War.

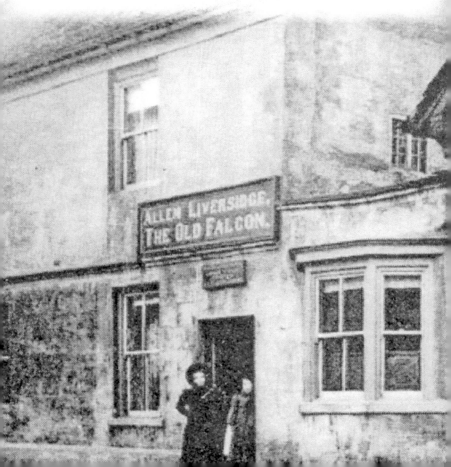

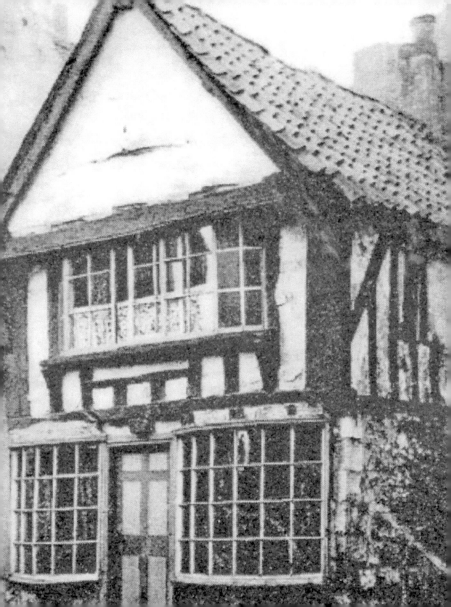

19. DEATH ROW, c. 1918

This bull is soon to meet its end at Hilltop Butcher's in aptly named Oxton Lane. The picture, from 1918, shows Harry Shilleto, who was born in Tadcaster in the 1880s and died aged ninety-four. He opened the butcher's in 1914 and went on to run Golf Links Farm. Part of the butcher's is in the background of the photo. It was originally the Rose & Crown public house, a former coaching inn that became a private residence after 1850. It was demolished in the 1970s to make way for the Hillside housing estate.

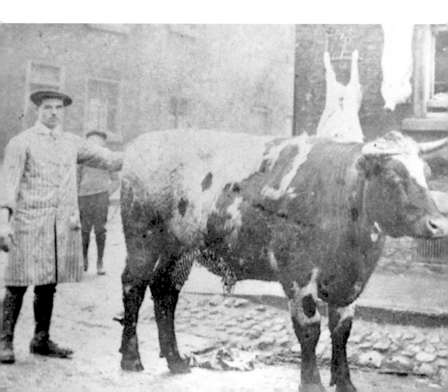

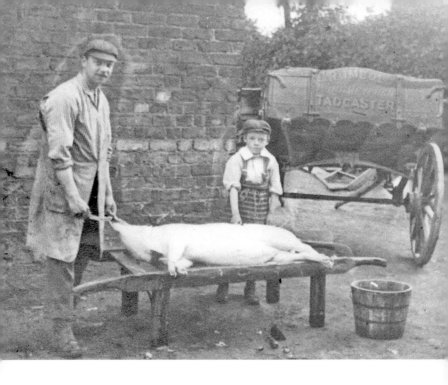

20. BUCKETS OF BLOOD

The photograph captures a butcher (Crumbold's?) at work on a pig in the 1930s. Note the blood bucket.

21. ALLEN'S IRONMONGER'S

The ironmonger's run by John Allen in Bridge Street opened in 1851 and stayed in the family until the 1980s. Tin baths, oil paints, lawnmowers, tyres and, as the sign here shows, fireworks were all for sale. The shop continues to this day.

22. TADCASTER AND DISTRICT CO-OPERATIVE SOCIETY

The Tadcaster Co-op pre-1910, before the bakery and butchery departments moved into two houses to the left of the shop. This picture shows three proud members of staff from the grocery department. Pelaw Polishes seem to have a monopoly on the window advertising, even over the Ideal evaporated milk and women's fashion displays. The Co-op closed in 1984.

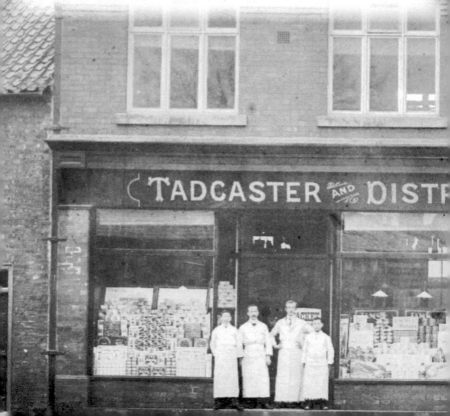

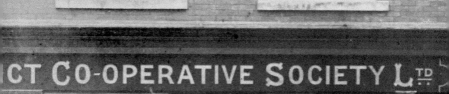

23. WILSON'S THE COBBLER'S, YORK ROAD, 1928

An intriguing shot of this cobbler's and a good example of a business being run from home. Tadcaster was one of England's first post towns – where horses were changed in a kind of relay between major towns, in this case the road between London and Edinburgh via York. In the mid-1600s the postmaster was a Mr Taylor, landlord of the Swanne Inn. The journey to London took four days and cost 40s. In 1880 fifty stagecoaches passed through Tadcaster with thirty or so stopping to change horses.

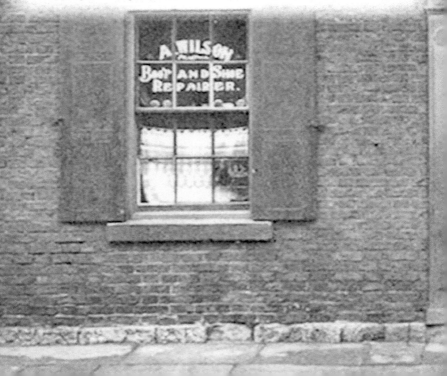

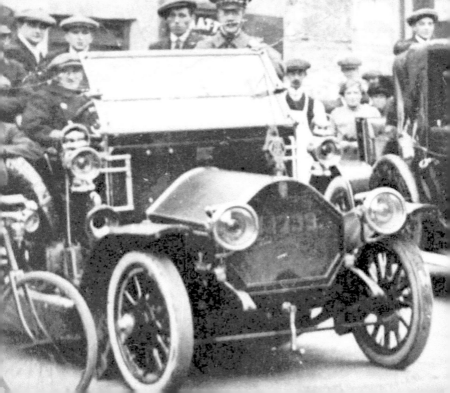

24. G. H. MOON

A 1914 shot of Market Place with a splendid display of motorcars – the one in the middle is the John Smith's Brewery car with the chauffeur, Harry Linfoot, on its right. Next door to Moon's was Miss Couch's tearooms and confectioners, who provided 'excellent temperance refreshments for cyclists' according to an advertisement of the time. Moon's also sold garden equipment.

25. BECKETT'S BANK

An early 1900s shot of workers, domestic staff and shoppers outside Beckett's Bank at the bottom of Kirkgate. The bank had moved into the premises formerly occupied by the Co-op, which moved to the top of Chapel Street. Beckett's was founded around 1750 in Leeds and at its peak had thirty-seven branches. The bank eventually became the Wakefield & Barnsley, and then Barclays. Beckett's survives to this day as a pub in Park Row, Leeds, in an old Beckett's Bank building. A different bank occupies the site today.

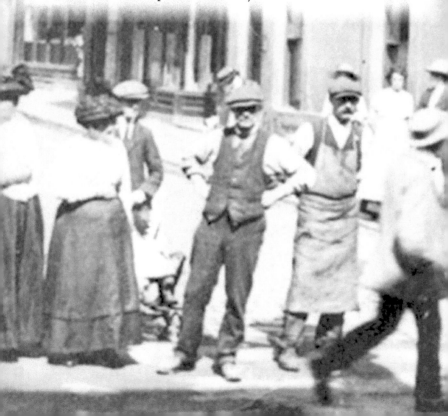

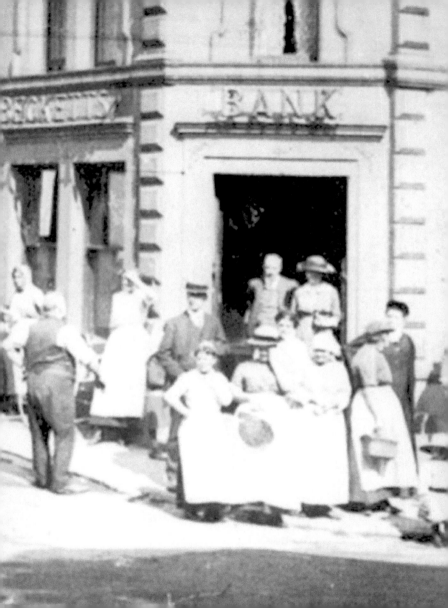

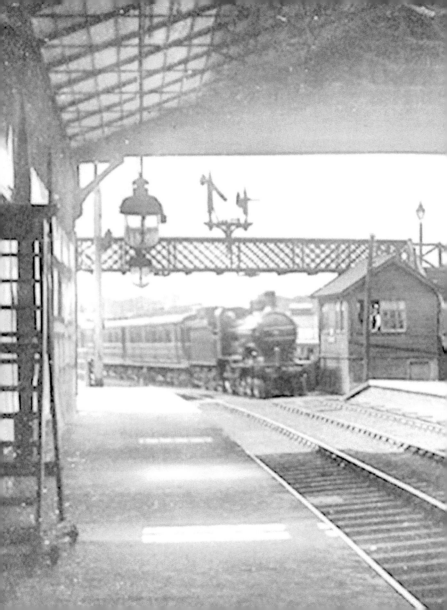

26. TADCASTER STATION, 1915

Tadcaster station was on the line between Church Fenton and Harrogate, which opened in 1847 and was owned by the York & North Midland Railway. It was designed by G. T. Andrews, the architect responsible for the elegant de Grey Rooms and the Bar Convent façade in York. The goods yards and station occupied over 8 acres between Station Road and Leeds Road. In 1854 it was staffed by a stationmaster, eight labourers and two porters. In 1911, 30,000 tickets were sold and there were nine trains in each direction by 1932. During the war the line served the munitions factory at Thorp Arch. The station closed to passenger traffic in 1964 and was demolished (despite its designation as a listed building) later to make room for the station industrial estate.

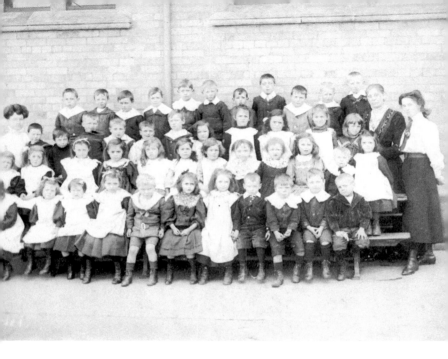

27. TADCASTER BOARD SCHOOL, 1921

School photograph time for pupils at the board school in Station Road. The school was built and opened in 1877 and survived until 1984, when it transferred to Riverside Primary School in Wetherby Road. Teachers Misses Deighton and Holgreaves can be seen at either end of the second row from the back. Miss Kettlewell, the headmistress, is on Miss Holgreaves' right. A not altogether joyous occasion it seems in 1921.

28. TADCASTER GRAMMAR SCHOOL

Taken around 1915, this image shows the grammar school on the corner of Leeds Road (formerly Lady Pitts) and London Road. The John Smith's chimneys can be seen in the background with the cattle market in between. Previously, the building was occupied by Henrietta Dawson's Girls' School, which was founded in 1888 and offered girls domestic economy, laws of health, drill and geometry as well as the usual subjects. In 1906 Oglethorpe merged with Dawson and became known as Tadcaster Grammar School. An inspection in 1909 was highly critical with one of its recommendations being that 'the wall between the boys' playground and the cattle market should be raised because it is not high enough to prevent unseemly interruptions'.

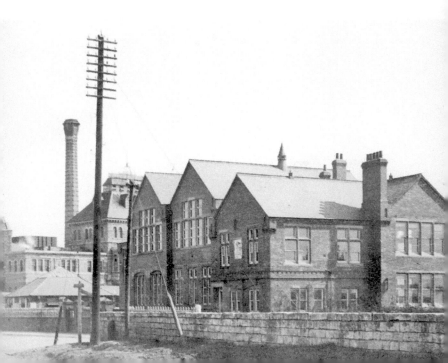

29. SUNDAY SCHOOL

The Sunday school here in Westgate opposite the Calcaria pub around 1900 is possibly the oldest such building in England, having been built in 1788 and paid for by public subscription. The *York Courant* reported: 'The Sunday Schools at Tadcaster met with incredible success, where very many of both sexes attend the Church and the School to learn their duty to God and Man, who before lived in gross neglect or open profanation of the Lord's Day – it is to be wished that other towns and villages would follow this laudable example.' The building was also used for a time by the Dawson School. Today it is occupied by Selby College Learning Centre.

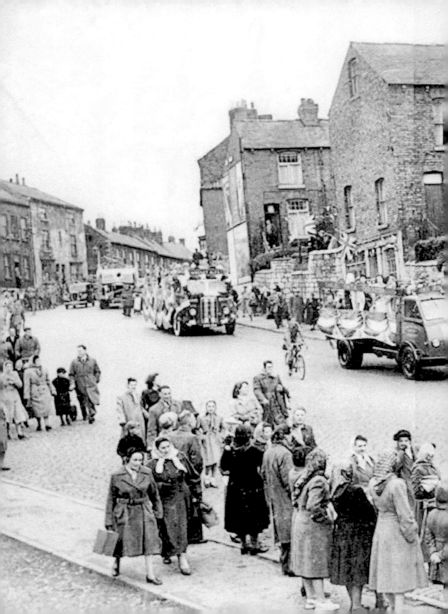

30. COMMERCIAL STREET CORONATION CELEBRATIONS

Celebrations in Commercial Street for Elizabeth II's coronation in 1953. Tadcaster's nearby marketplace goes back to 1270 when Henry de Percy obtained a royal charter from Henry III to hold 'a market and fair at his manor of Tadcaster' every Tuesday. This ancient marketplace was at the present-day junction of Kirkgate and Bridge Street. A stone base, which was part of the original market cross, used to stand on Westgate where the Tadcaster war memorial is now. Today's market is held on Thursdays in the car park of Tadcaster Social Club on St Joseph's Street.

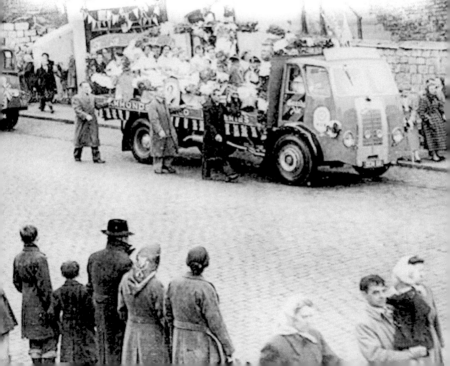

31. BRIDGE STREET FLOODS, 1950

Bridge Street once flooded quite frequently. Here we can see improvised means of transport sailing down the street. Celia Fiennes, in 1697, describes Tadcaster and her flooding in the late seventeenth century: 'This stands on a very large River Called the Whart. Just before you Come to ye town there is some of ye water wch on Great raines are not to be pass'd – it was very deep when I went through.'

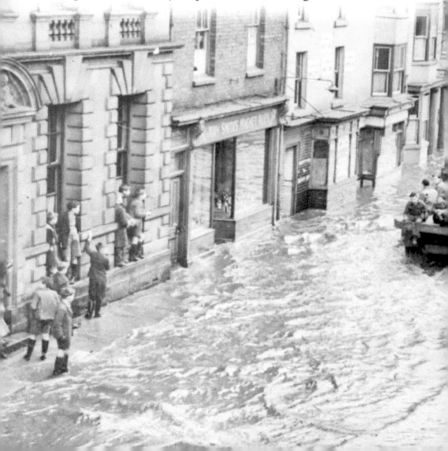

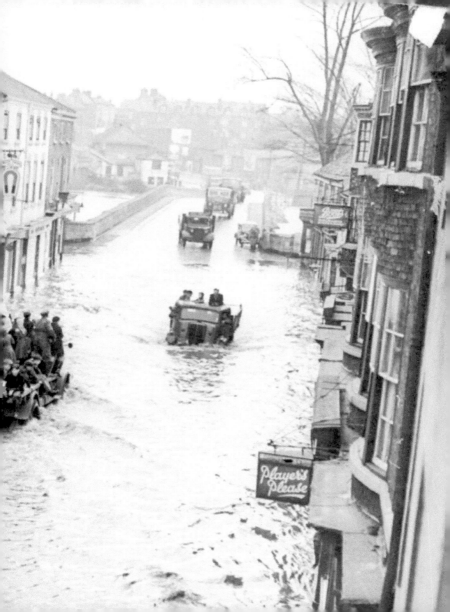

32. TADCASTER WAR MEMORIAL, 1921

The commemorative service for the new war memorial built in 1921 on the site of the old market cross. Westgate is in the background. The memorial remembers twenty-six fallen in the First World War and twenty-five in the Second World War; those fallen in the first war lost their lives in the following battles: Passchendaele, Gallipoli, Persia, India, Mons, Somme, Ypres, and Alexandria.

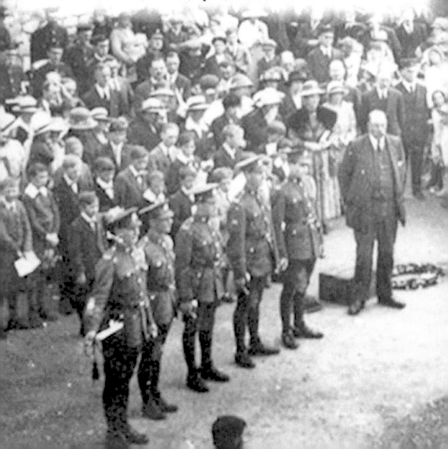

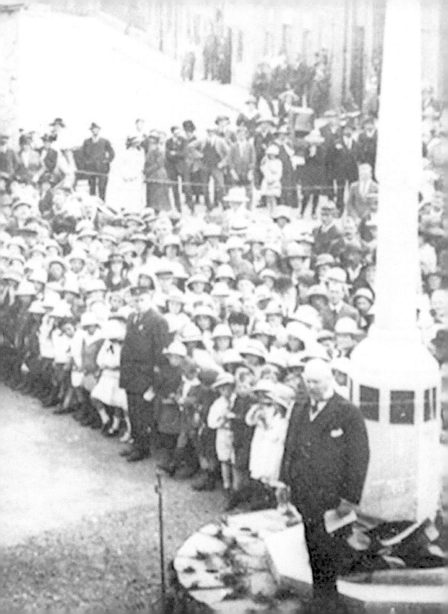

33. YORK ROAD

York Road in 1913 looking towards York. The Travelling Man pub is on the right with Parkland Drive further up.

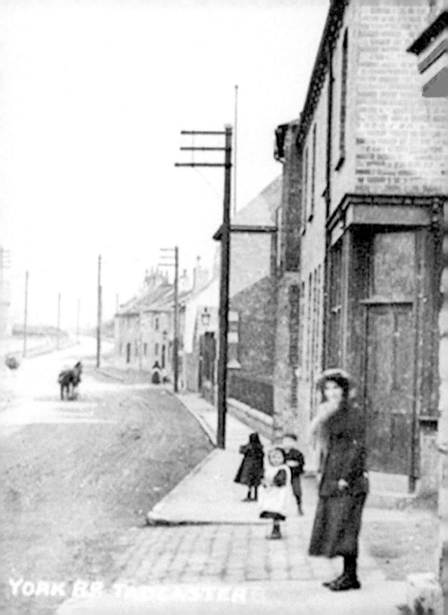

YORK RD TADCASTER

34. COMMERCIAL STREET, 1907

A group of children gathered here on Commercial Street with the Britannia, owned by John and William Dyson, and the Coach & Horses (originally the Half Moon) pubs on the left. A 1901 advert shows us that it was keen to attract the emerging cyclists' market, calling itself the 'Cyclists House – Dinners, Teas and Refreshments provided for Cyclists and Parties.' Dyson's brother William lived over the bridge at No. 1 Bridge Street; he left money in his will to pay for the Salvation Army citadel in Chapel Street, which was known as Dyson's Tabernacle. William Dyson was also owner of river barges. The pub was named after their 90-ton keel boat, which shipped the first ever cargo of John Smith's beer to Hull for delivery to Amsterdam, where it won a gold medal in 1895. Baron Londesborough sold the Britannia in 1873 to John Smith's for £900: 'Public House ... stables, cowhouse and shed, cottage and warehouse, in occupation of Ann Dyson.'

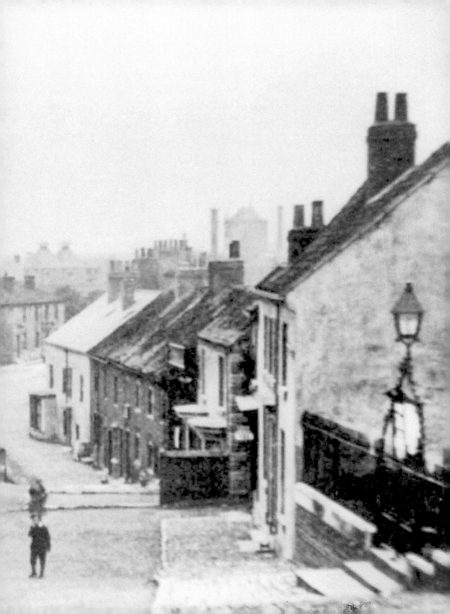

35. BRIDGE STREET SPIRIT STORE

The shop on the left is W. Clever, tobacconist and confectioner, with
Barclays Bank next to that. The next building, No. 24, is John Smith's
spirit store. Bought in 1924, it featured a hoist for deliveries to the
three floors. The hoist, trap doors and winding gear are still in the
building today.

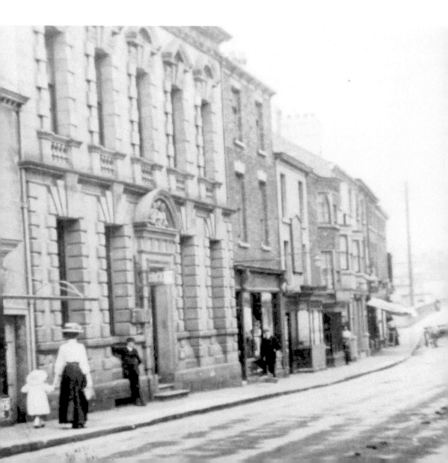

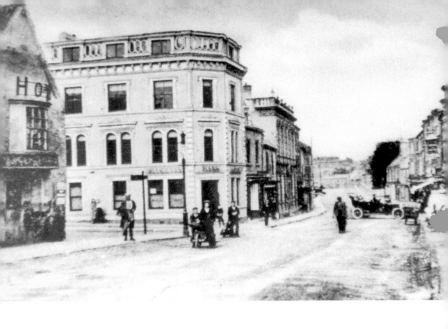

36. BRIDGE STREET

What looks like an early attempt at a three-point turn can be seen in this photograph. The first building in Bridge Street used to be the Anchor, originally the Hope & Anchor, used by boatmen working on the river. The Golden Lion was also nearby, but is now gone. The lion is the Lion of Flanders, emblematic of the fact that the hop was introduced to England from Belgium. The White Swan, however, has survived – at one time owned by a Joseph Middleton, who lived through the reigns of several monarchs: George III, George IV, William IV, Victoria and Edward VII. He was born in 1815 just before the Battle of Waterloo and died in 1901. The green-tiled White Hart was nearby at No. 22. The NatWest bank is in the building once occupied by Beaumont's grocers and Beckett's Bank.

37. REGAL CINEMA AND THE SUNDAY SCHOOL

The Regal opened in 1938 in Westgate and replaced the Cosy Cinema in the High Street. There was room for 670 cinemagoers but queues extending down Westgate into Kirkgate were still a common sight. The premiere was *Maytime* starring Nelson Eddy and Jeanette Macdonald. Seats cost 1s 3d, and 2s 6d; the children's matinee on Saturday mornings cost 7d. The Regal closed in 1976 with a showing of *Where Eagles Dare*. It was demolished in 1986.

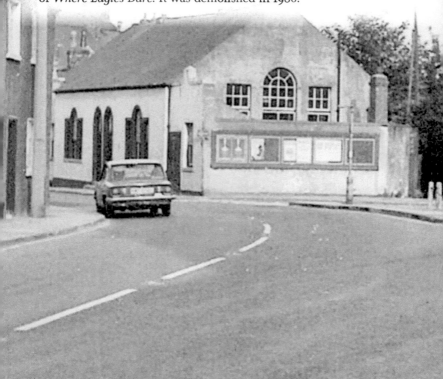

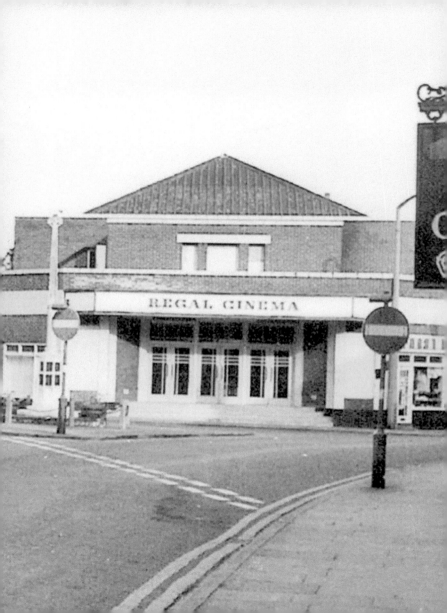

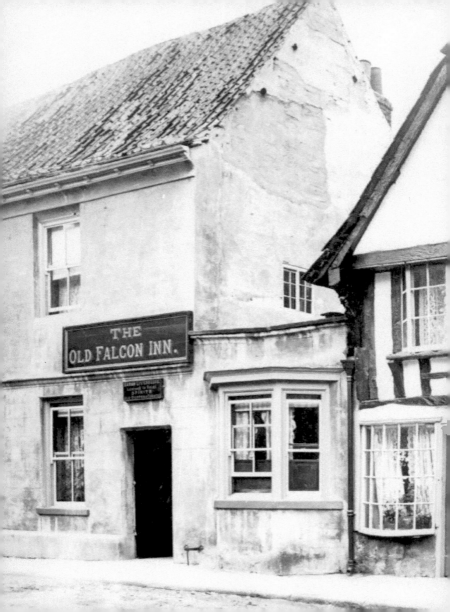

38. THE ARK

Noah's Ark, part of a much larger fifteenth-century building, got its name from the carved heads of Noah and Naamah, his wife, on corbels at the front of the building. In 1672 it was known as Morley Hall after Robert Morley, who managed to get it licensed for Presbyterian meetings. It is reputedly where the Pilgrim Fathers met to plan their emigration to America. There is an exact copy of the Ark in Berlin Center, Ohio, which is dedicated to providing a permanent safe haven for unwanted and abused exotic animals. In the nineteenth century the Ark became a carpenter's shop, until it was bought in 1959 by W. H. D. Riley-Smith and eventually became a museum until 1984, a museum again in 1985 to 1989, and offices of Tadcaster Town Council from 1992. To the left was the Old Falcon Inn, run in 1844 by Thomas Liversedge, a lime burner as well as publican – Tadcaster's last free house until it was bought by John Smith's in 1942.

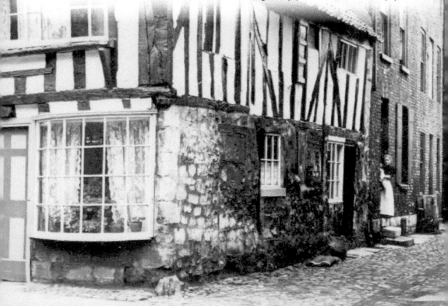

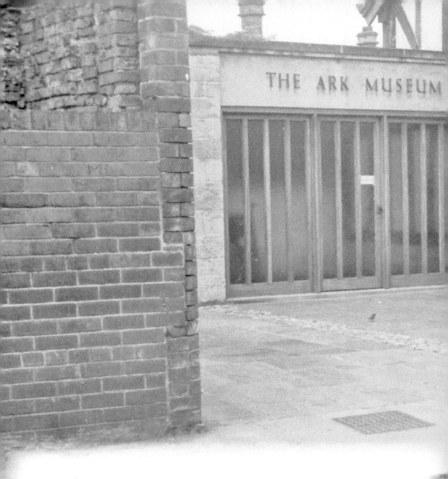

39. THE ARK MUSEUM

The block at right angles to the street is known as the solar after the solar range that was there. In the nineteenth century this became a carpenter's shop until it was bought in 1959 by W. H. D. Riley-Smith and eventually became a museum until 1984.

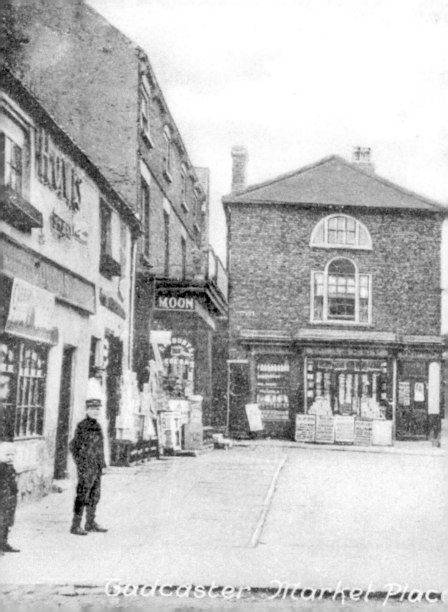

Tadcaster Market Place

40. MARKET PLACE

Taken in 1908, this clearly shows C. Woodson's café and sweetshop on the left with the big Hovis and refreshments signs, then G. H. Moon's grocery; Askey's stationers, library and printers is directly opposite (later Grimston's). George Tindall's plumbers is on the right to the left of the shop with the awning and Barber's House Furnishers next to that in the building once occupied by the Railway Hotel. George Tindall was nothing if not versatile, offering his services as glazier, gas, water and steam fitter, bell hanger, plumber, sanitary, and electric light engineer. Barber's later became Barber & Turner's – a toy as well as a furniture shop. This is where Mr Rodgers of the Tower Brewery bought queues of boys and girls a present of their choice on Christmas Eve.

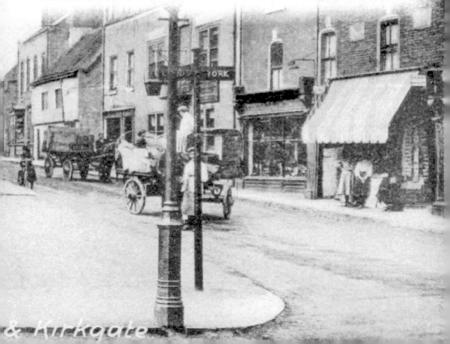

& Kirkgate

41. BRAMHAM PARK GROUNDS

This baroque mansion was built in 1698 by Robert Benson, 1st Baron Bingley, and has remained in the family ever since. It is situated in a landscaped park replete with follies and avenues in the eighteenth-century landscape tradition. After a fire in 1828, the house remained derelict until its restoration in 1908. It remains a private residence today, although you can visit by appointment, and the 400-acre park is the venue for the annual Bramham Horse Trials and Leeds Festival. The inset image shows agricultural workers at Bramham around 1901.

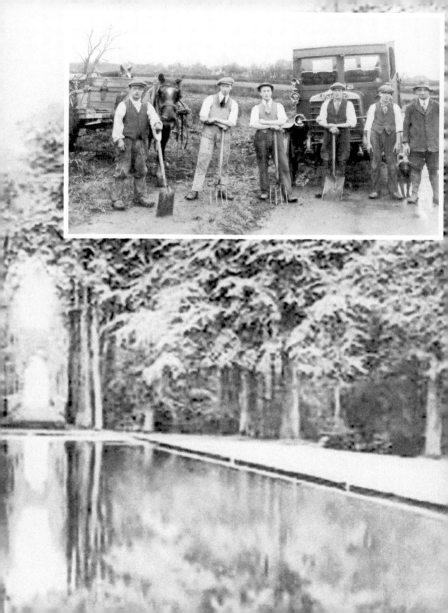

42. THE SPA BATHS, BOSTON SPA

In 1744 John Shires discovered magnesian, limestone and sulphur springs and so made Boston a spa town, known then as Thorp Spaw, but it declined around the same time as Harrogate's fame was increasing.

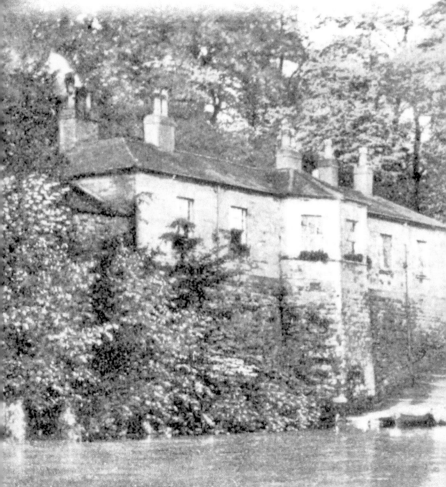

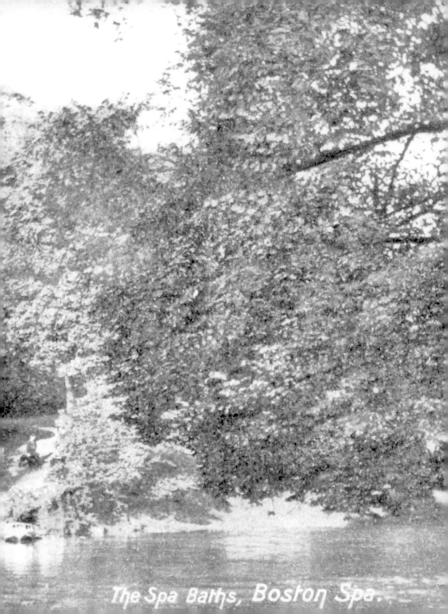

The Spa Baths, Boston Spa.

43. JACKDAW CRAG

Jackdaw Crag Quarries (some miles away near Stutton) is the main quarry for the highly sought-after Tadcaster limestone, which was used in the construction of York and Beverley minsters, Selby Abbey, York's city walls, some of the colleges at the University of Cambridge and nearby Hazlewood Castle. The quarry was in fact owned by the Vavasours of Hazlewood Castle and it was they who donated free stone to York Minster after the 1829 fire.

Jackdaw Crag, Boston Spa.

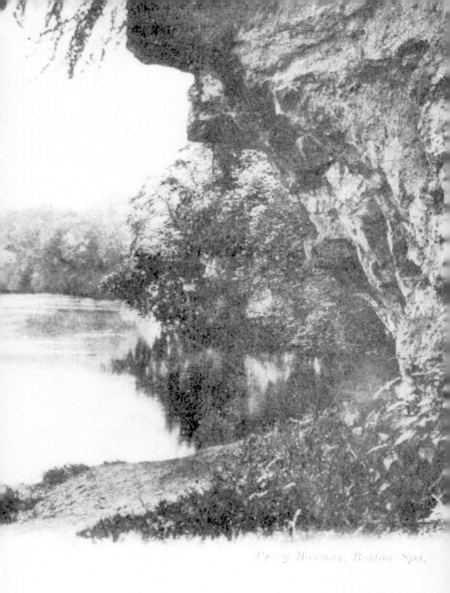

Percy Robinson, Boston Spa.

44. ADMIRAL HAWKE HOTEL, BOSTON SPA

One of the many English pubs named after Edward Hawke (1705–81), famous for his service during the Seven Years' War – particularly his victory over the French at the Battle of Quiberon Bay in 1759, preventing a French invasion of Britain. The story of Boston Spa started with the Royal Hotel being built by Joseph Taite and originally called Farrers Hotel after the owner; it was built in 1753 and is the oldest recorded building. The first house was St Kitts, in 1774. This was followed by Brook House in 1791 and Boston Hall in 1807. All have survived today, although Boston Hall is now occupied as offices. The photograph shows cavalrymen gathering outside the pub, which still survives today.

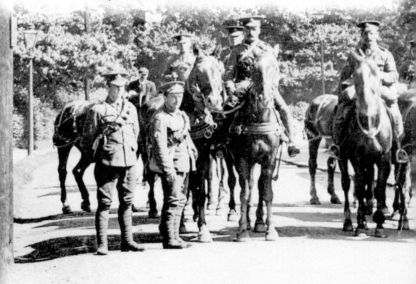

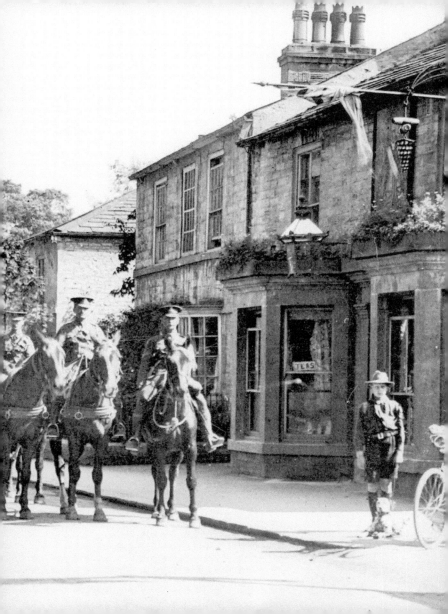

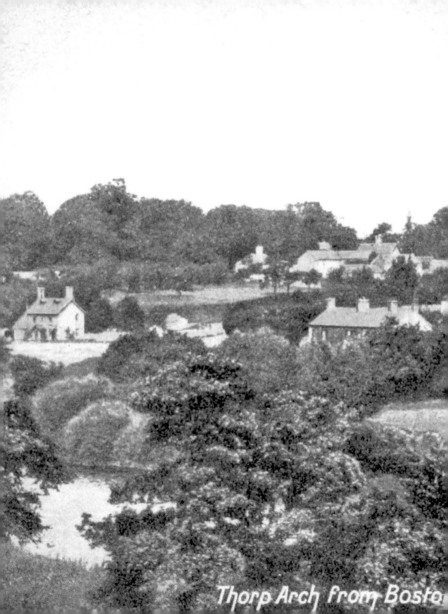

Thorp Arch from Bosto

45. THORPE ARCH FROM BOSTON SPA

During the Second World War, Thorp Arch was the home of a Royal Ordnance Factory ammunition filling factory. It produced light, medium and heavy gun ammunition, landmines and trench mortar ammunition for the Army; medium and large bombs for the RAF; and 20-millimetre ammunition and other small arms for all three services. Some of these were produced in millions and hundreds of millions of units. It finally closed in 1958 after the Korean War. Part of the site now houses the Northern Reading Room, Northern Listening Service and Document Supply Collection of the British Library. Over 100 kilometres of shelving is devoted to inter-library loans. The rest of the site is occupied by Thorp Arch Trading estate and two prisons, now combined with Wealstun Prison. Thorp Arch is mentioned in Domesday as a mill used by brewers in Roman times.

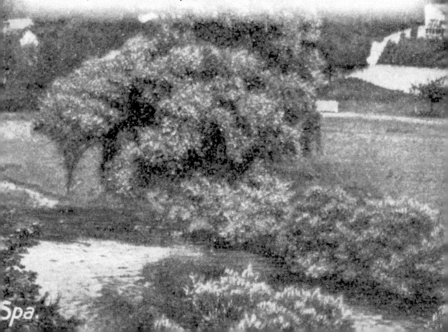

Spa.

46. ULLESKELF RAILWAY DISASTERS, 26 MAY 1906 AND 8 DECEMBER 1981

In 1839, 4 miles from Tadcaster, the station opened on the York & North Midland Railway. In 1981 the 13.50 p.m. York to Liverpool train took leave of the track at 70 miles per hour and careered down the embankment. Twenty-two passengers required hospital treatment. An incident on 4 October 2010 involved a 'bovine incursion' (cows on the line to you and me) when two cows were killed. Ulleskelf, derived from the Scandinavian, refers to Ulfr's shelf of land. In Domesday, Ulleskelf was known as Oleschel and was part of the Archbishop of York's land. In 1066 at the Battle of Fulford, Earl Edwin of Mercia moored his boats at Ulleskelf to prevent the invading army reaching York. An episode of *A Touch of Frost* was filmed in the village in 2008.

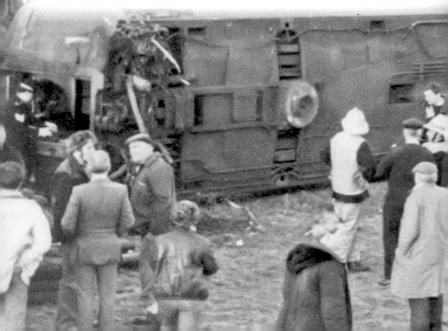

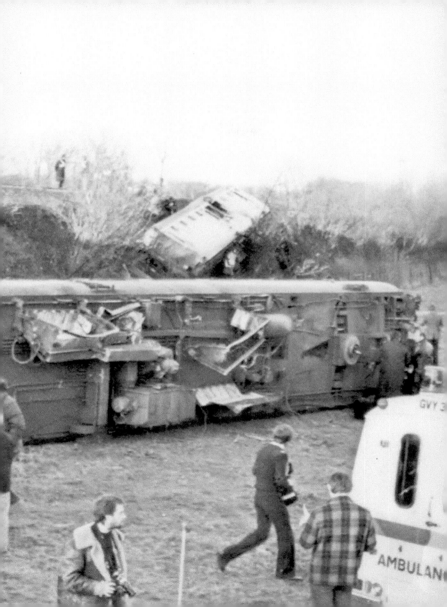

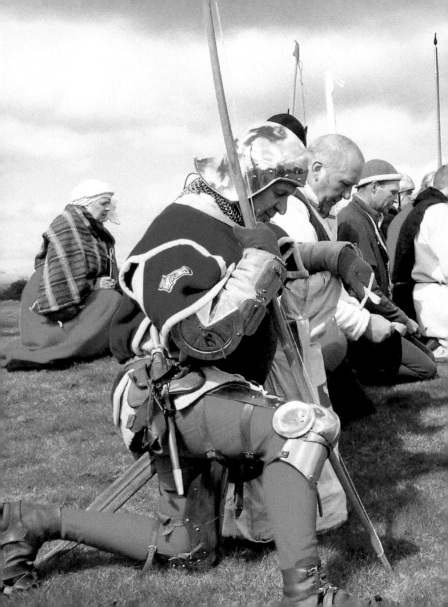

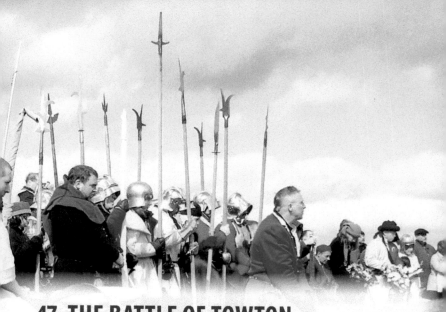

47. THE BATTLE OF TOWTON, 29 MARCH 1461 (PALM SUNDAY)

The Battle of Towton took place on 29 March 1461 between Towton and Saxton. It was a decisive victory for the Yorkists in the Wars of the Roses. Towton is the biggest battle ever fought in Britain: between 50,000 and 80,000 soldiers took part including twenty-eight lords – almost half the country's peerage. It was also the bloodiest battle ever fought in England, with up to 28,000 casualties, roughly 1 per cent of the population of England at the time. More probably died in the aftermath than in the battle itself, because neither side gave quarter and nearby bridges collapsed under the weight of the armed men. The worst slaughter was at Bloody Meadow, where fugitives are said to have crossed the River Cock using the bodies of the fallen as a bridge. The splendid modern reenactment is courtesy of the Towton Battlefield Society.

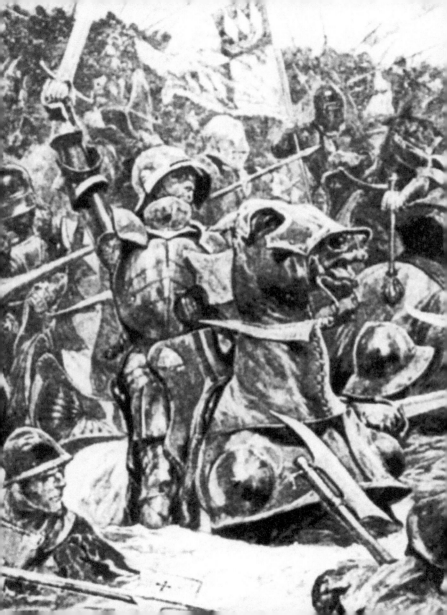

48. THE TOWTON MASS GRAVE

In August 1996 workmen uncovered a portion of a mass grave during building work at the Towton battlefield. A team of osteoarchaeologists and archaeologists from the University of Bradford and the West Yorkshire Archaeology Service recovered the almost complete remains of forty-three tightly packed casualties. Most had sustained multiple injuries from projectiles and hand-held weapons, exceeding what is necessary to cause disability and death. The distribution of cuts and chops indicate that blows were largely concentrated in the craniofacial area, in some cases bisecting the face and cranial vault or detaching bone; in other cases the nose and ears had been sliced off. The injuries were apparently intended to sufficiently mutilate the bodies as to make them unidentifiable. The engraving is by R. Caton Woodville.

49. THE WILD MAN

The Wild Man at Street Houses. Possibly originally called the Bush or something similar if the depositions of York Castle in 1675 are to be believed: Abraham Ibbotson of Leeds was charged with stealing horses, the felonious act being plotted at an alehouse in Street Houses 'in the way betwixt Tadcaster and York where there was a bush as a signe'. The bush was associated with the Roman god Bacchus, who was often depicted as a wild man on account of his characteristic state of frenzy and intoxication; the two symbols have become virtually synonymous. Legend has it that the almost life-sized sign used to be covered up with white calico when Queen Victoria passed by en route to York 'so that the Queen might not be shocked at the sight of so hairy (and naked) a man'. Id essequam, sam que expliquo estiAb idis

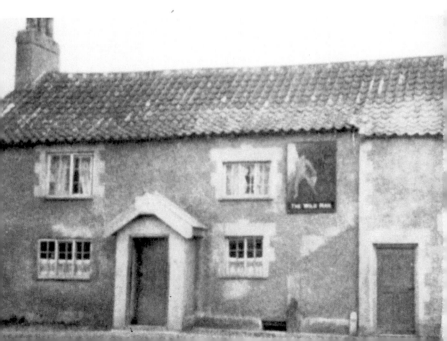